Meditative Coloring

By Melody Mort

Copyright © 2023 by DTS Publishing LLC, all rights reserved.
No part of this book may be reproduced without the express written permission of DTS Publishing LLC.

DTS Publishing is a Delaware limited liability company registered to do business in the State of Massachusetts in the United States of America.

Melody Morton © is a brand owned by DTS Publishing LLC and is registered in U.S. Patent and Trademark Office.

ISBN: 979-8-9875333-3-8

DTS Publishing LLC
991 Providence Hwy, Num 1116
Norwood, MA 02062
info@dtspublishing.com
www.dtspublishing.com

This book belongs to:

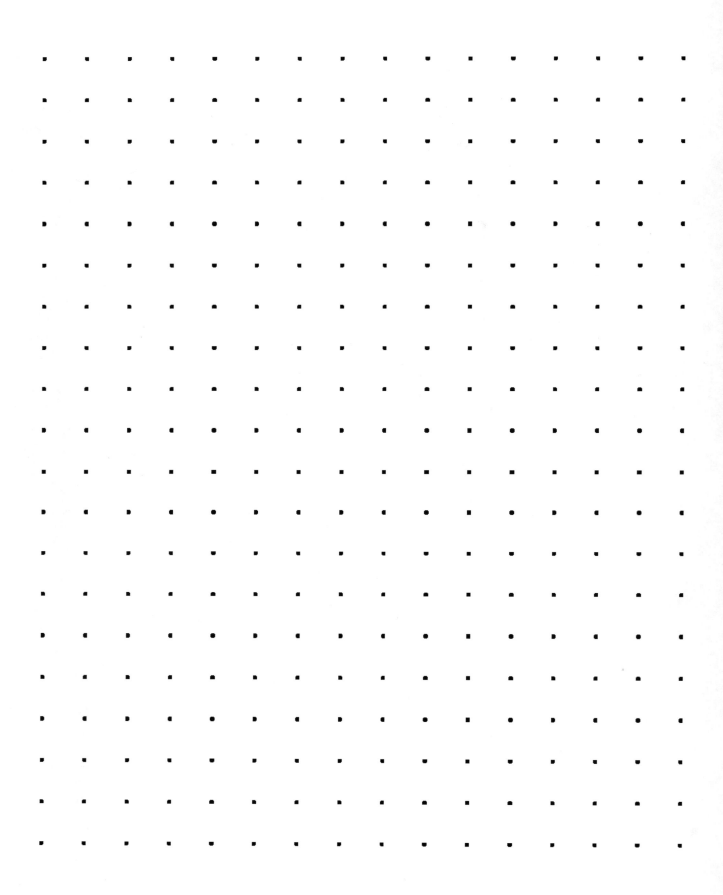

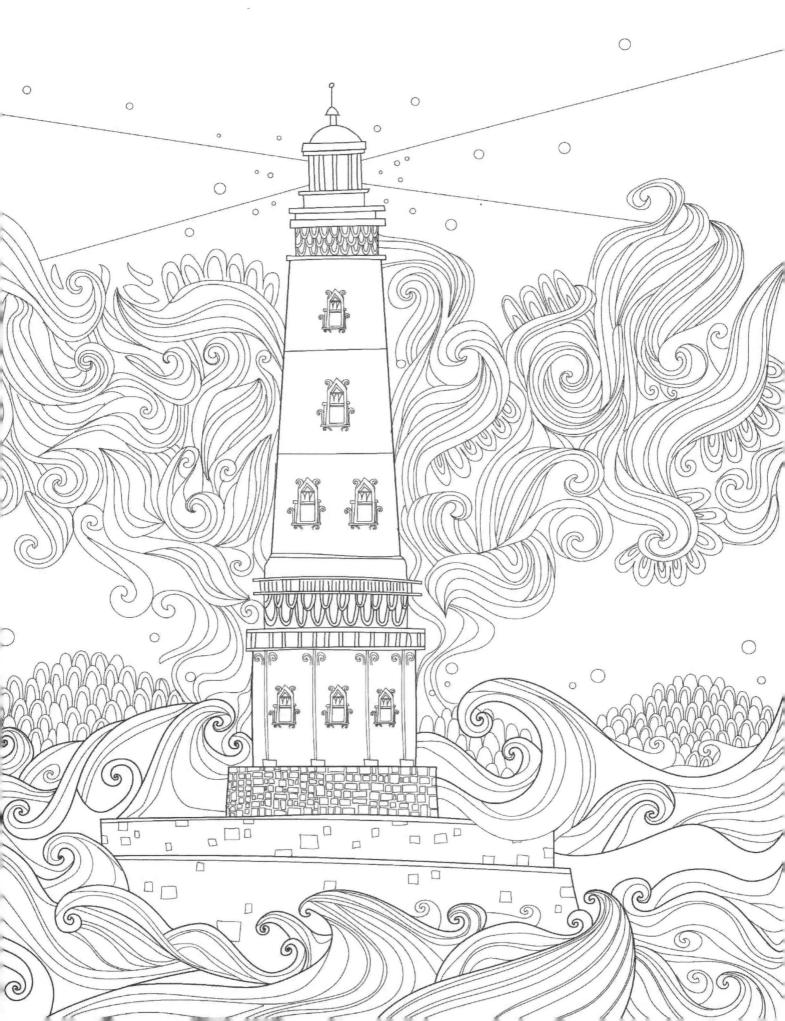

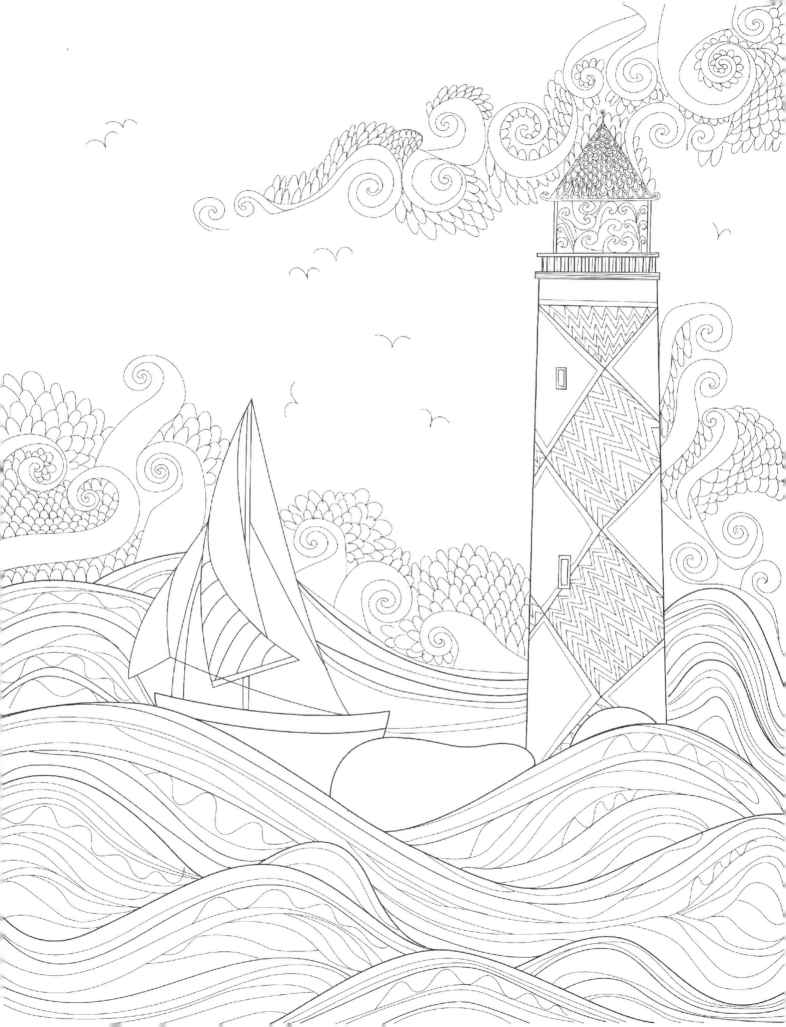

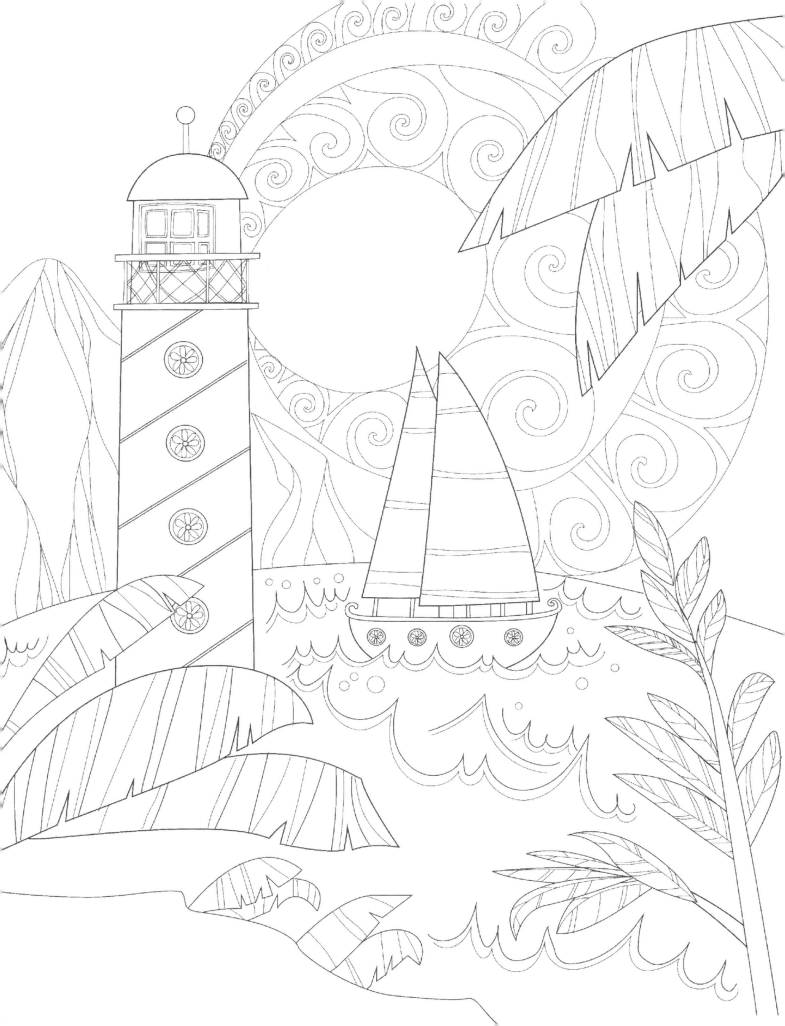

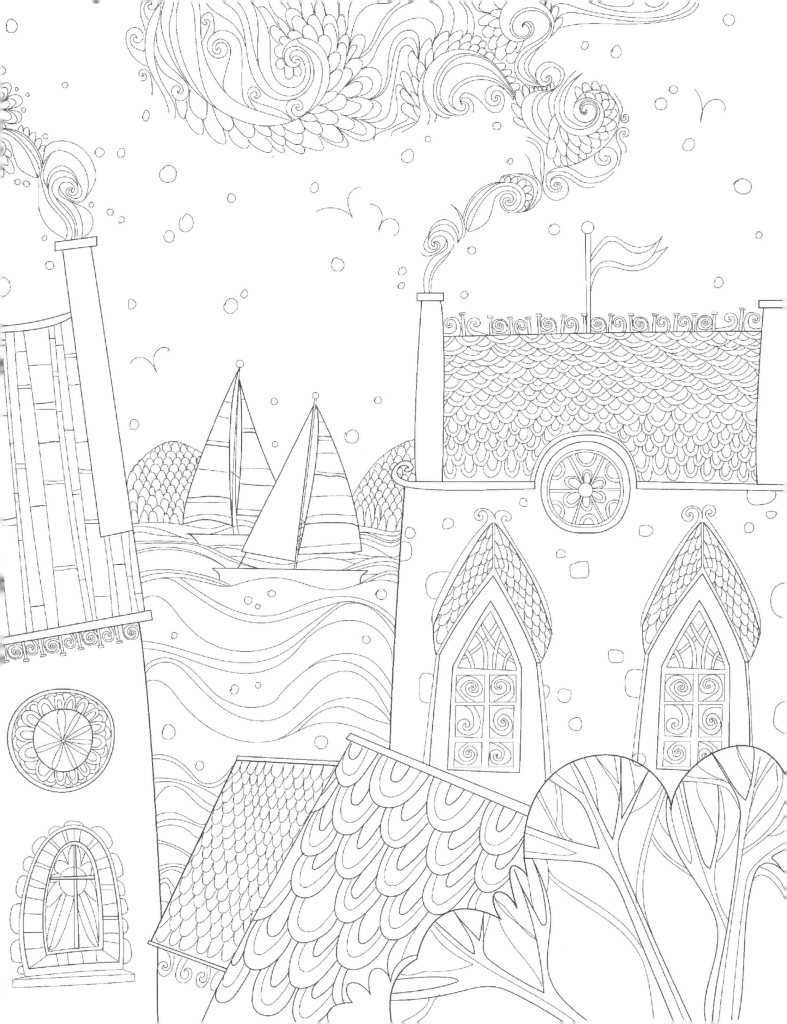

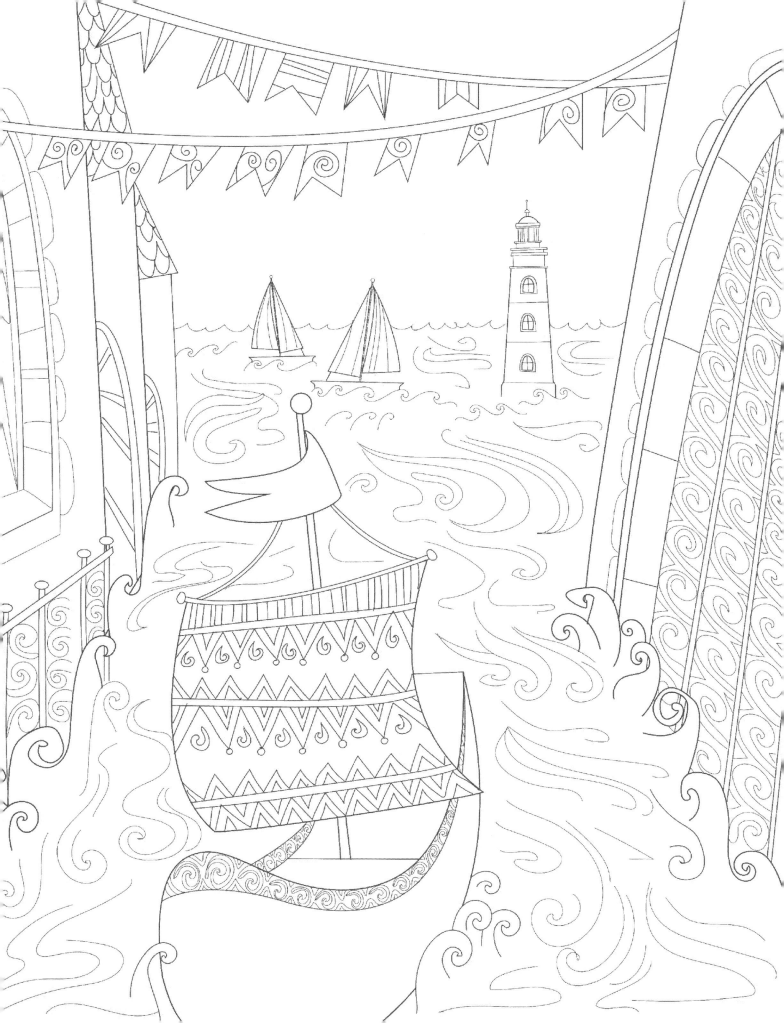

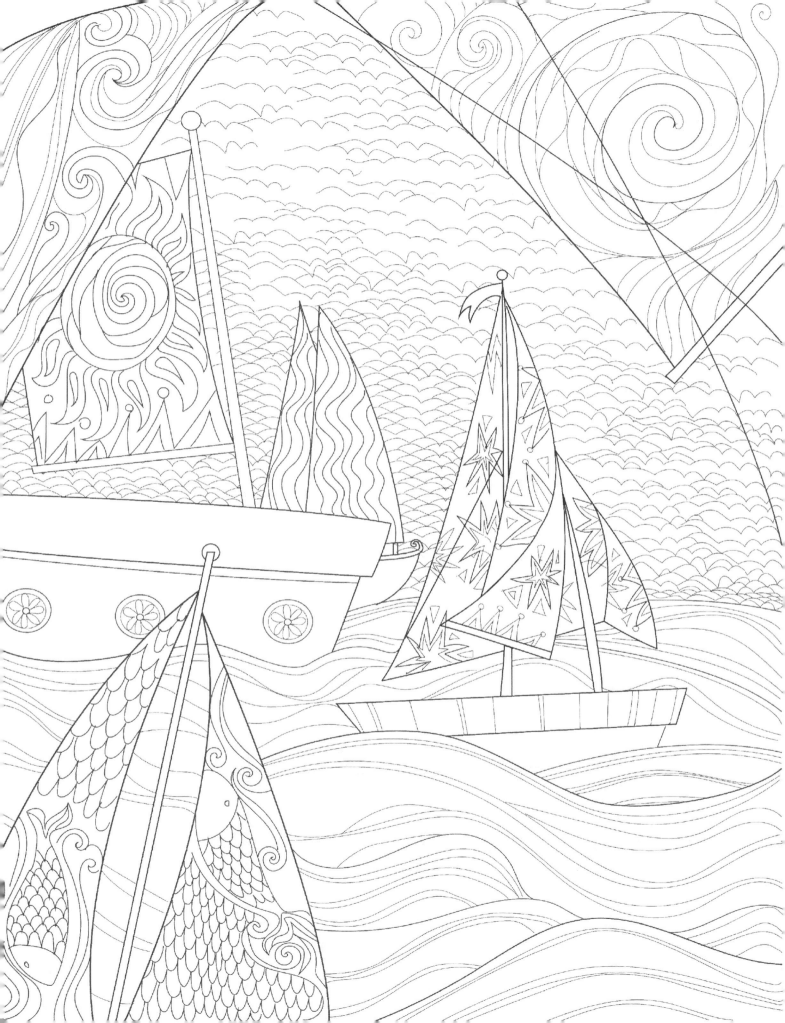

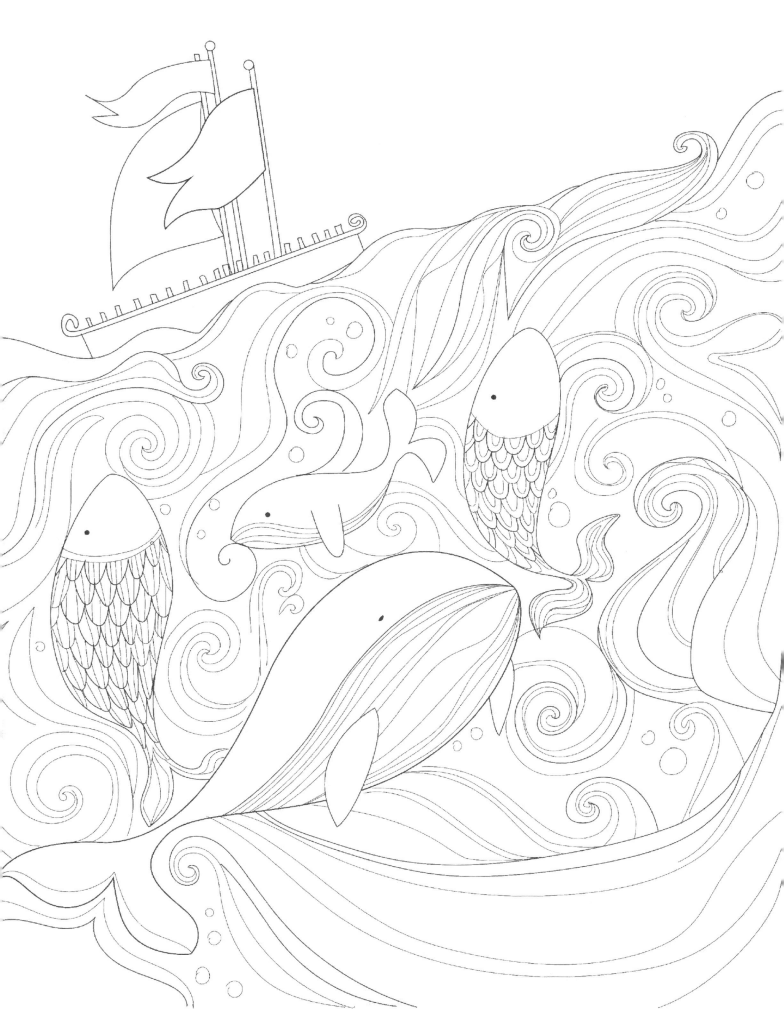

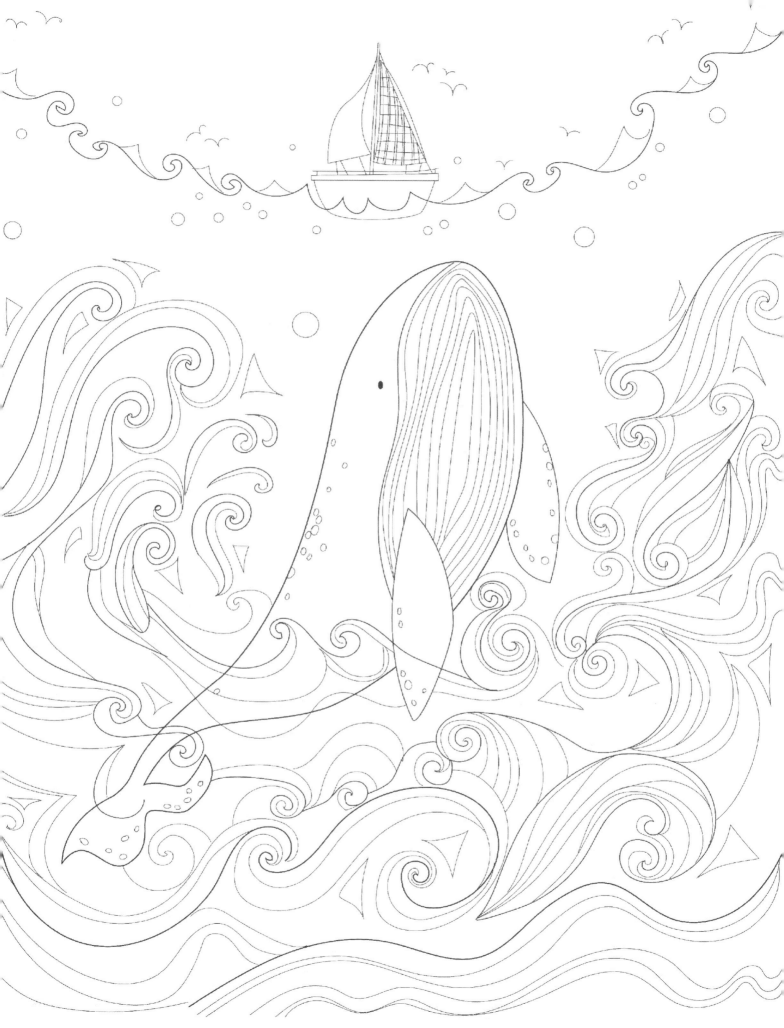

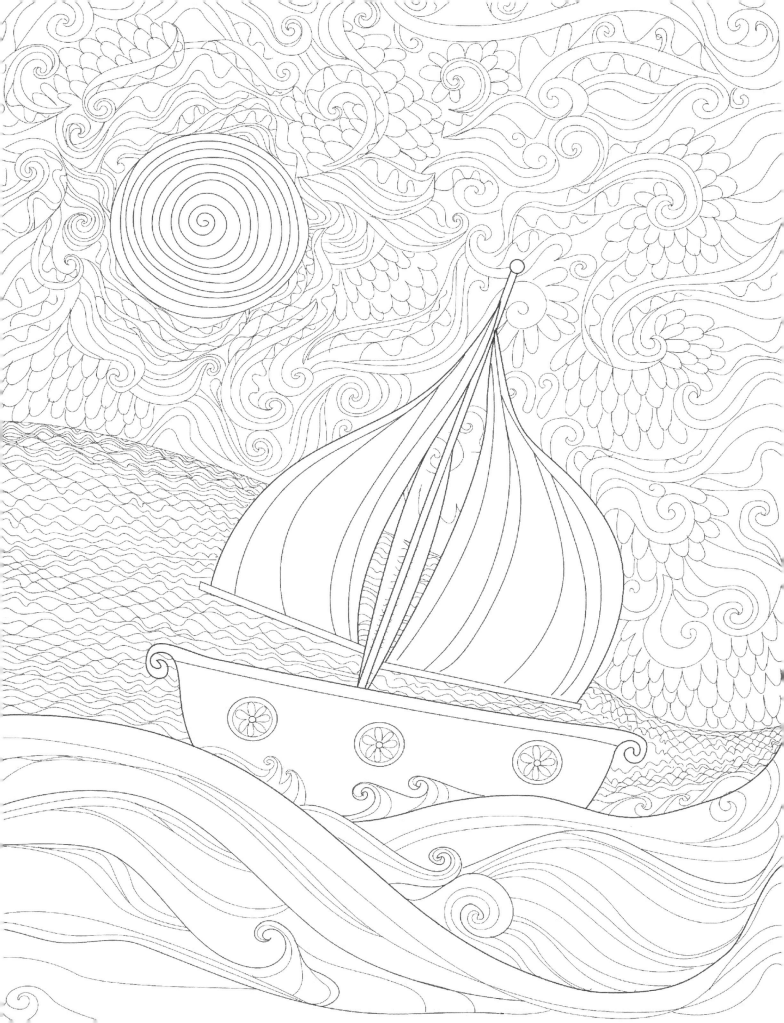

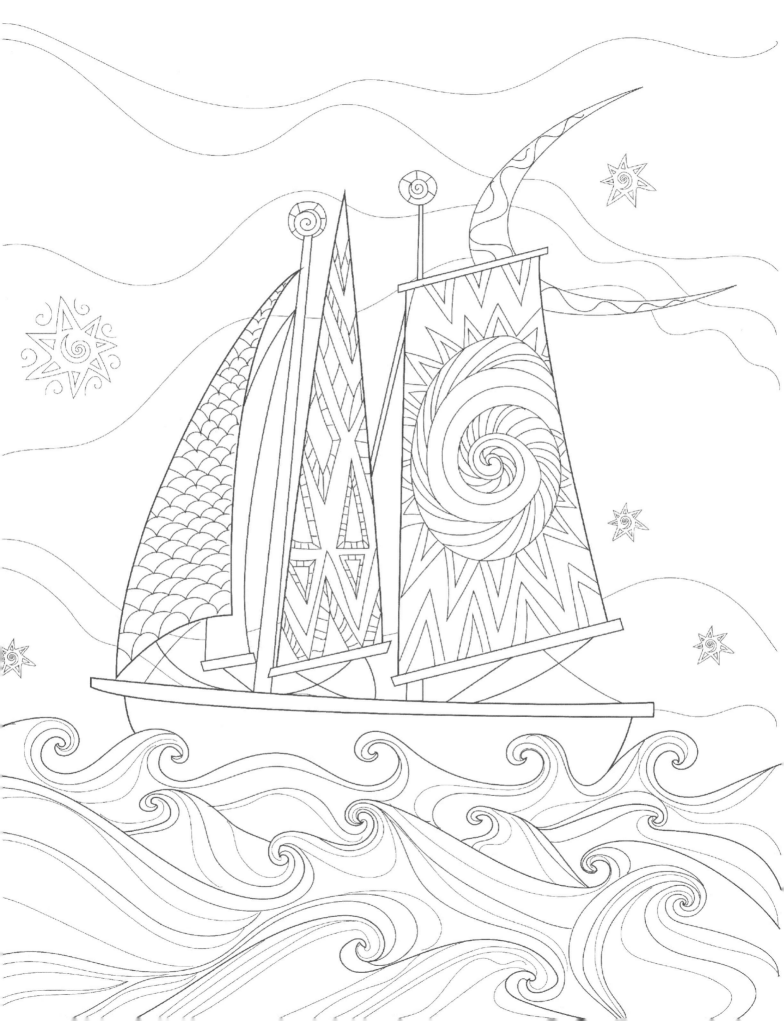

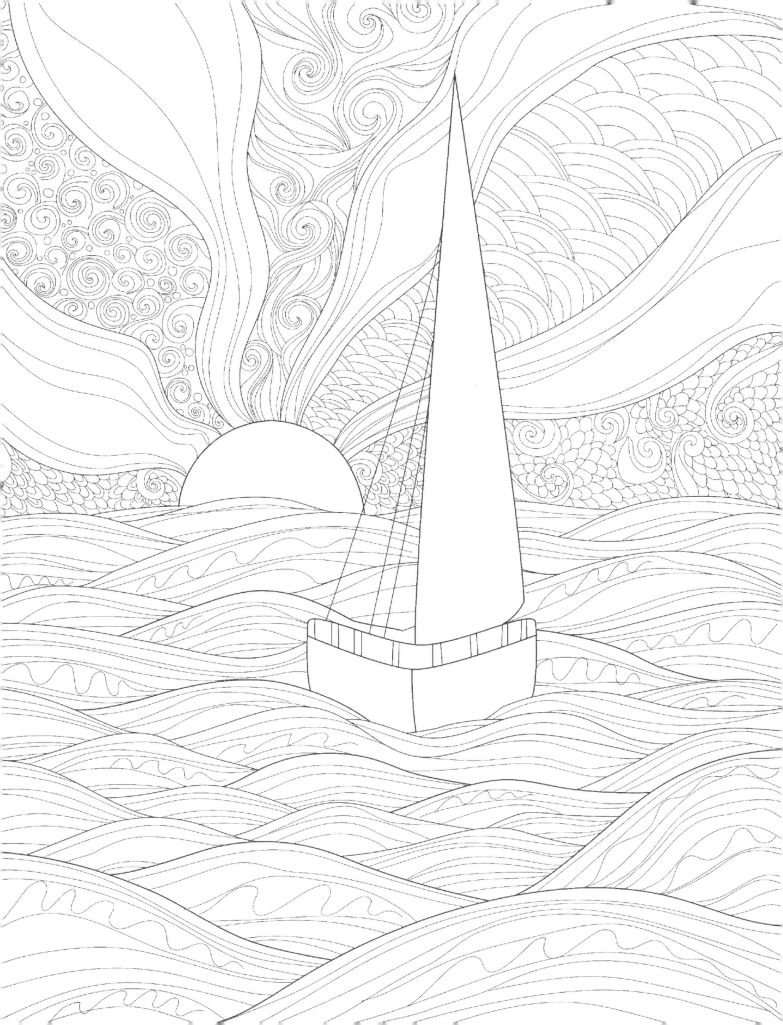

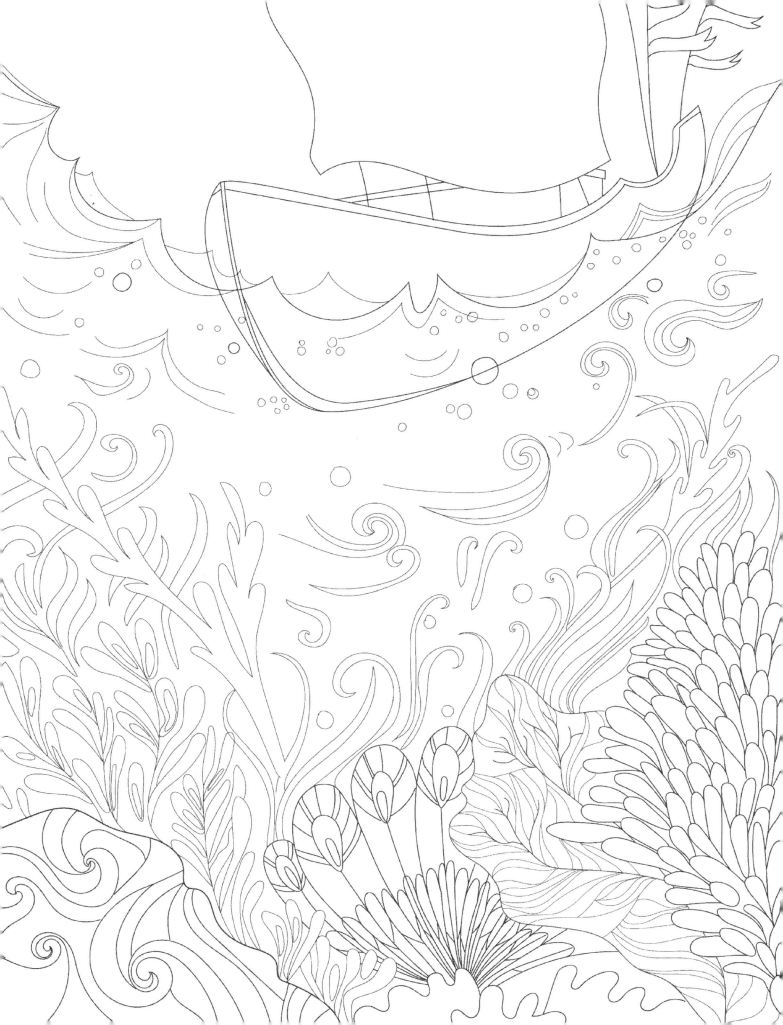

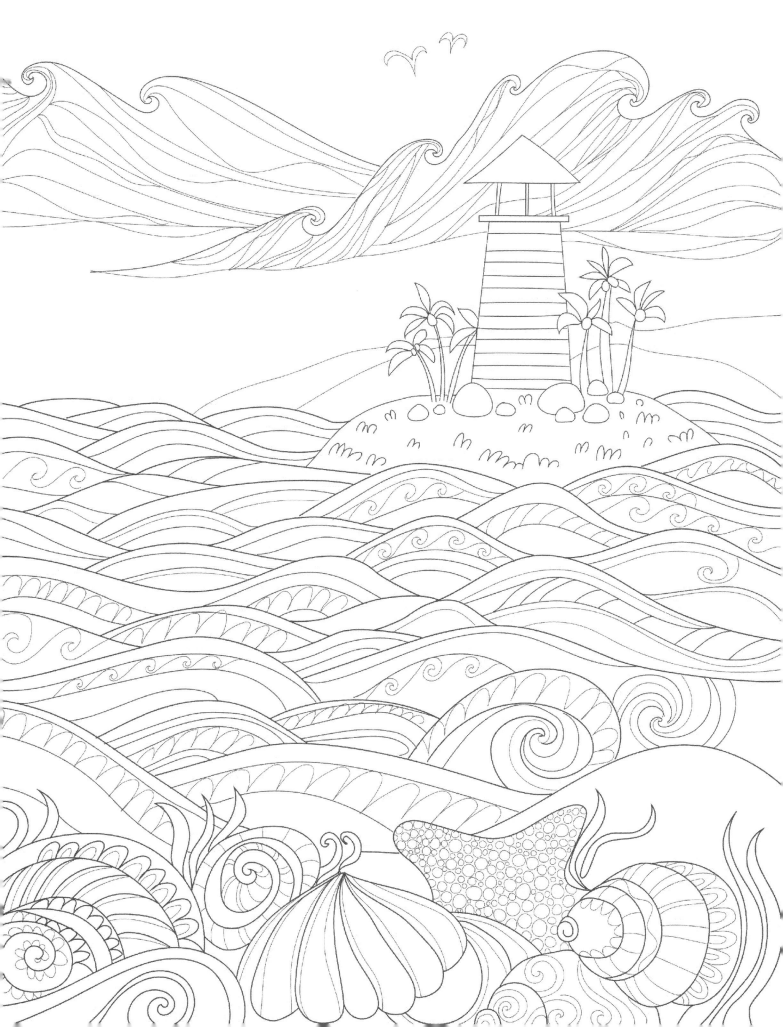

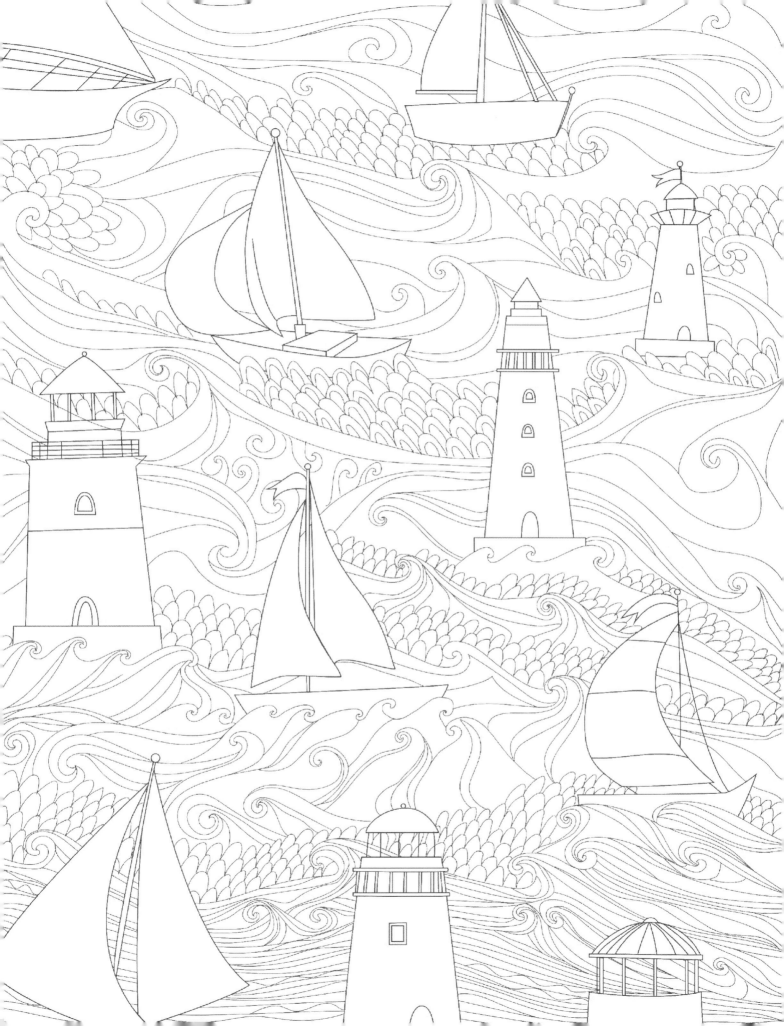

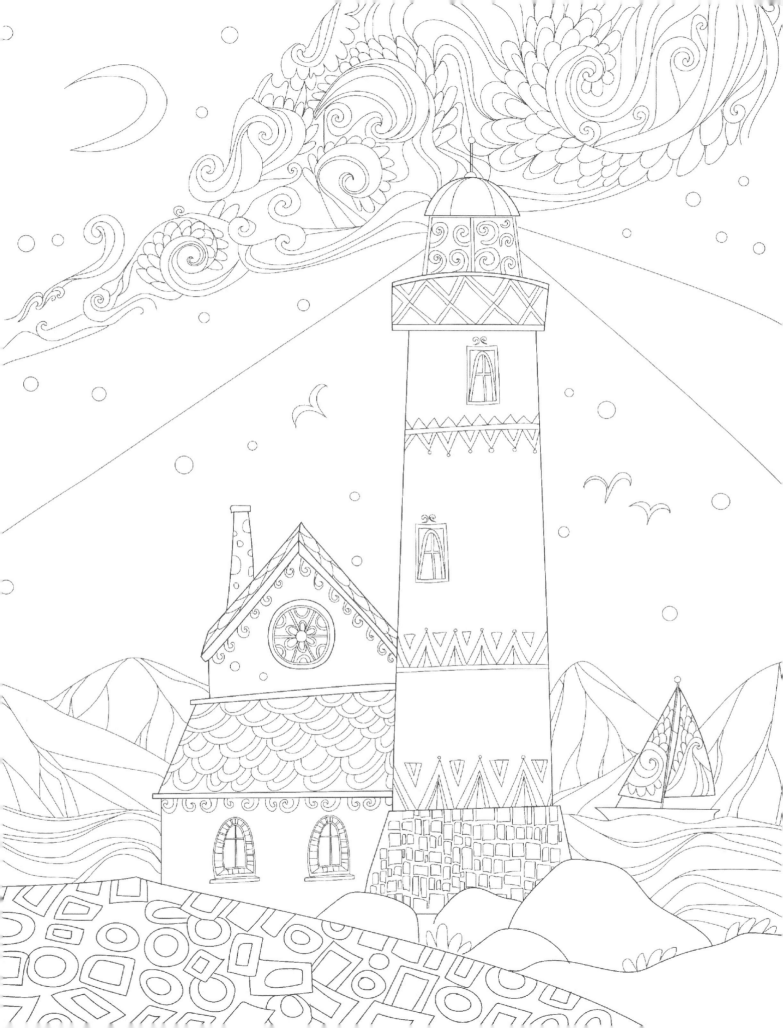

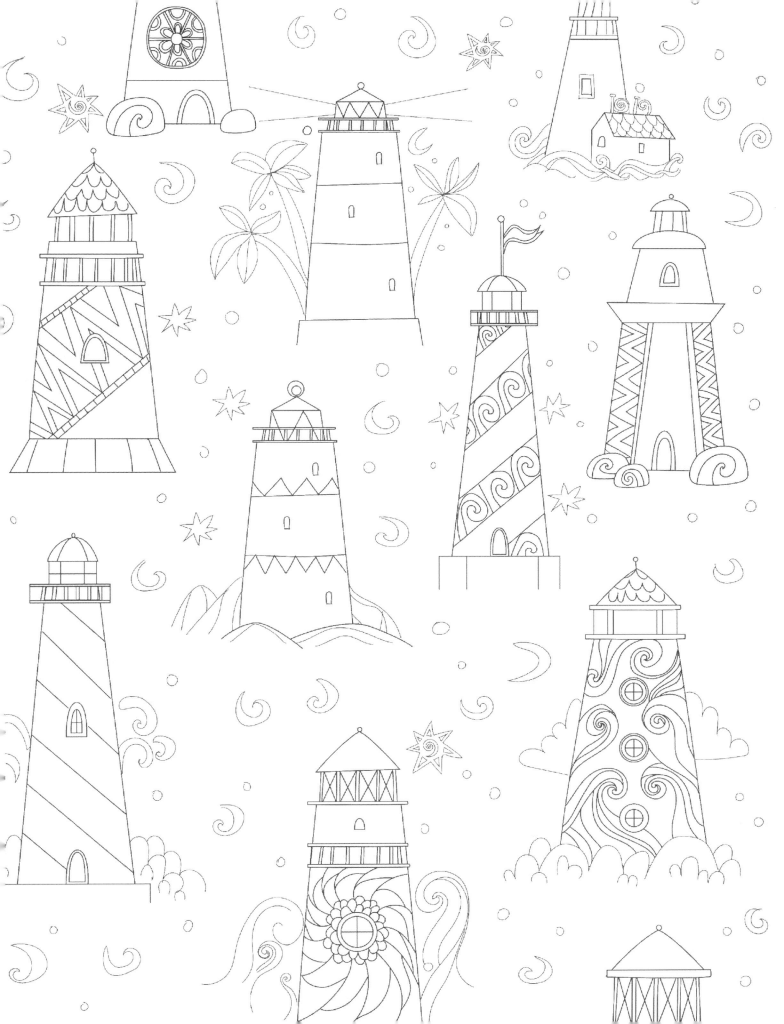

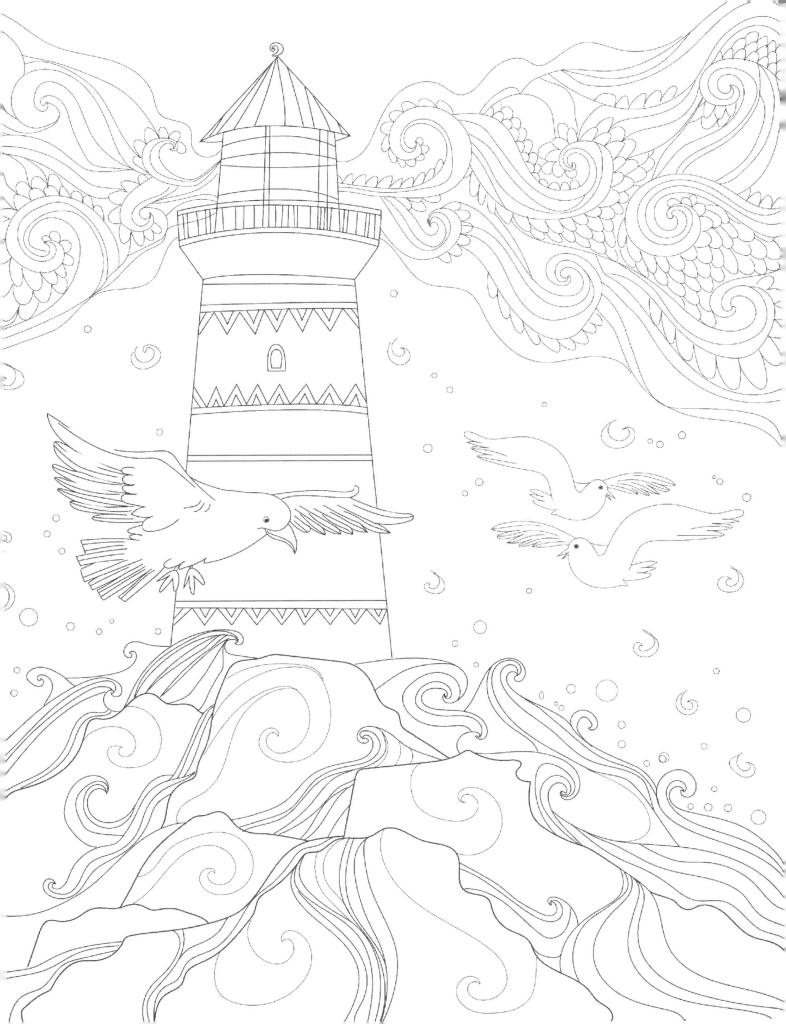

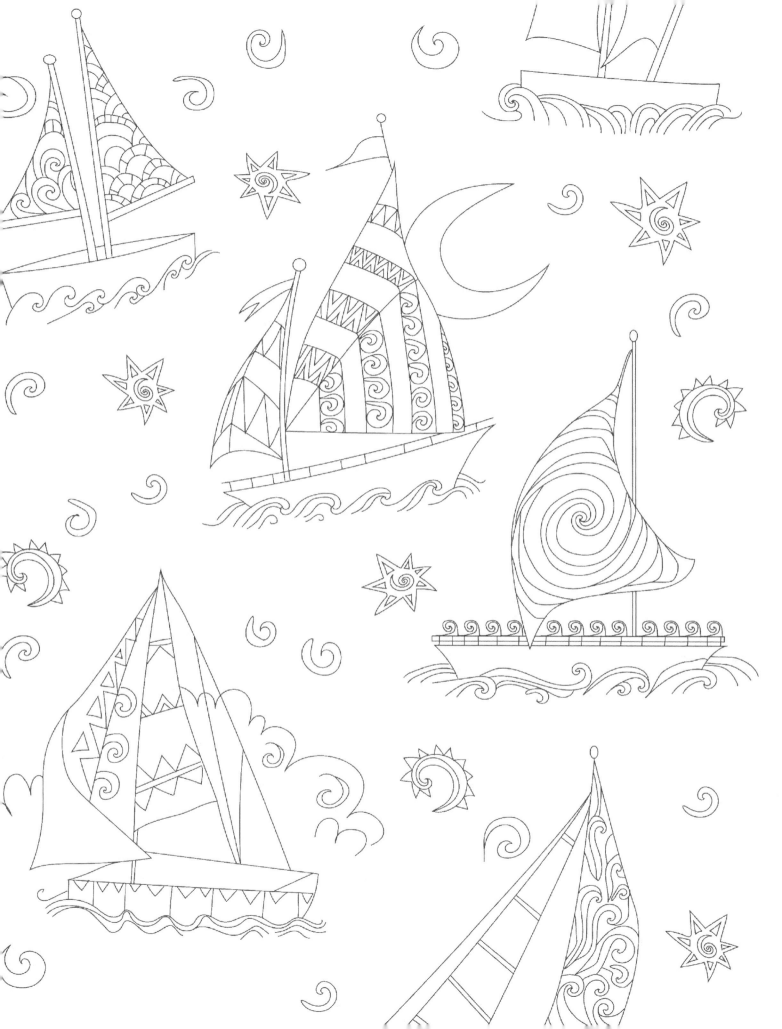

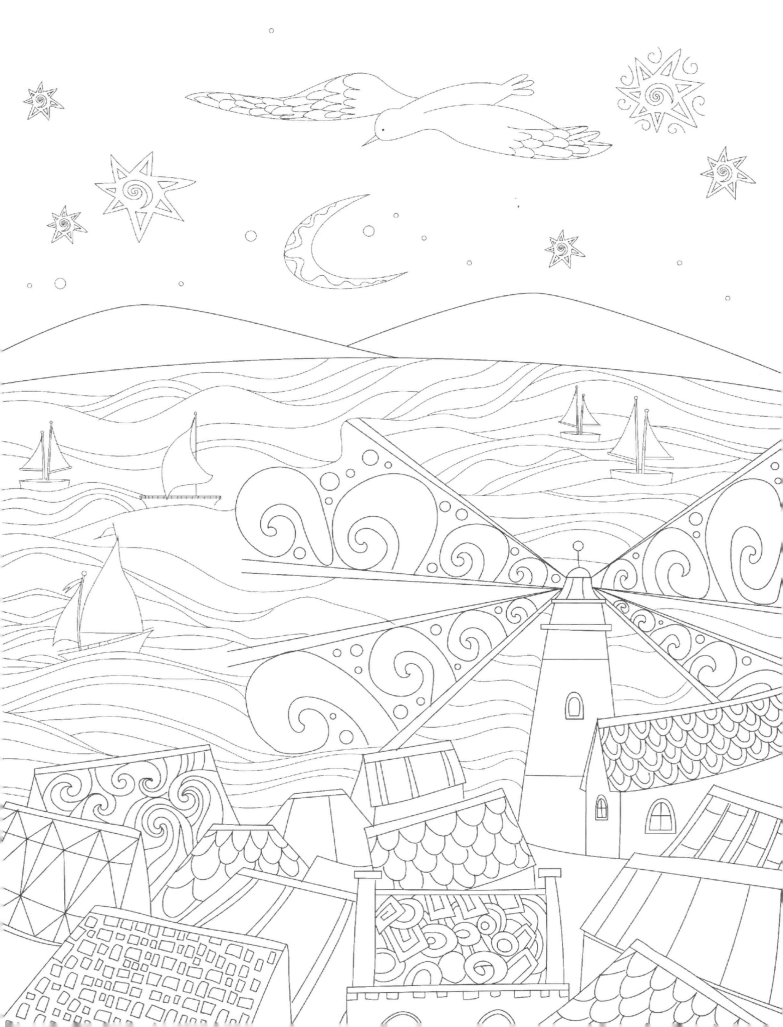

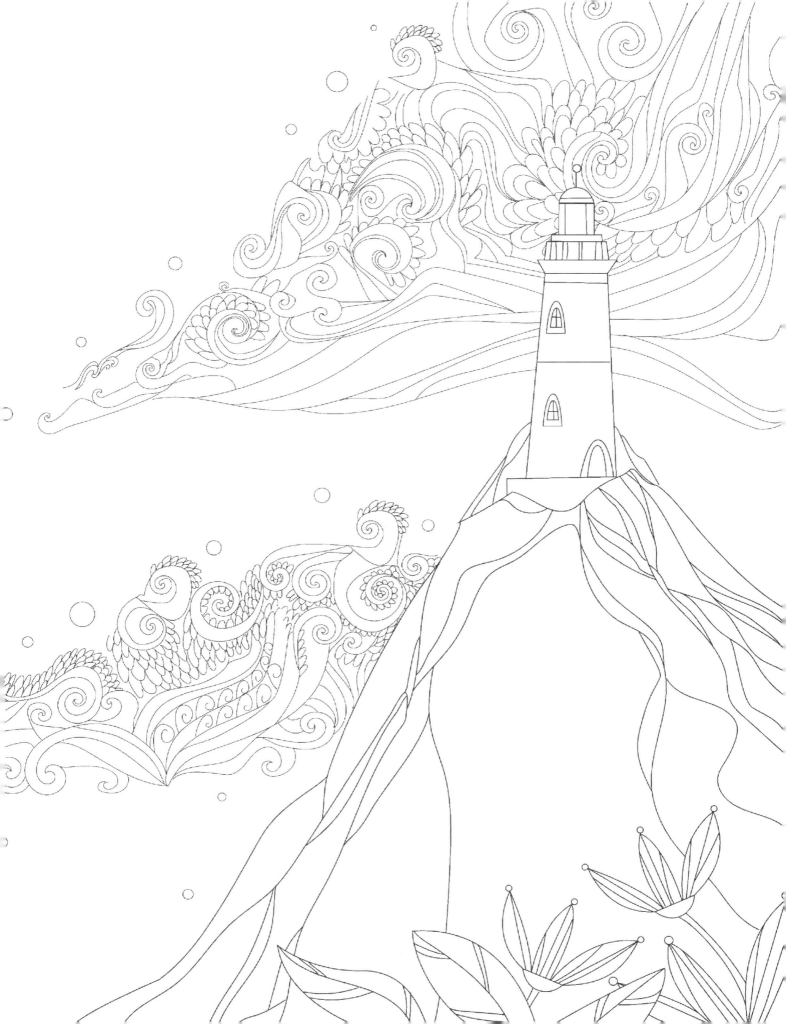

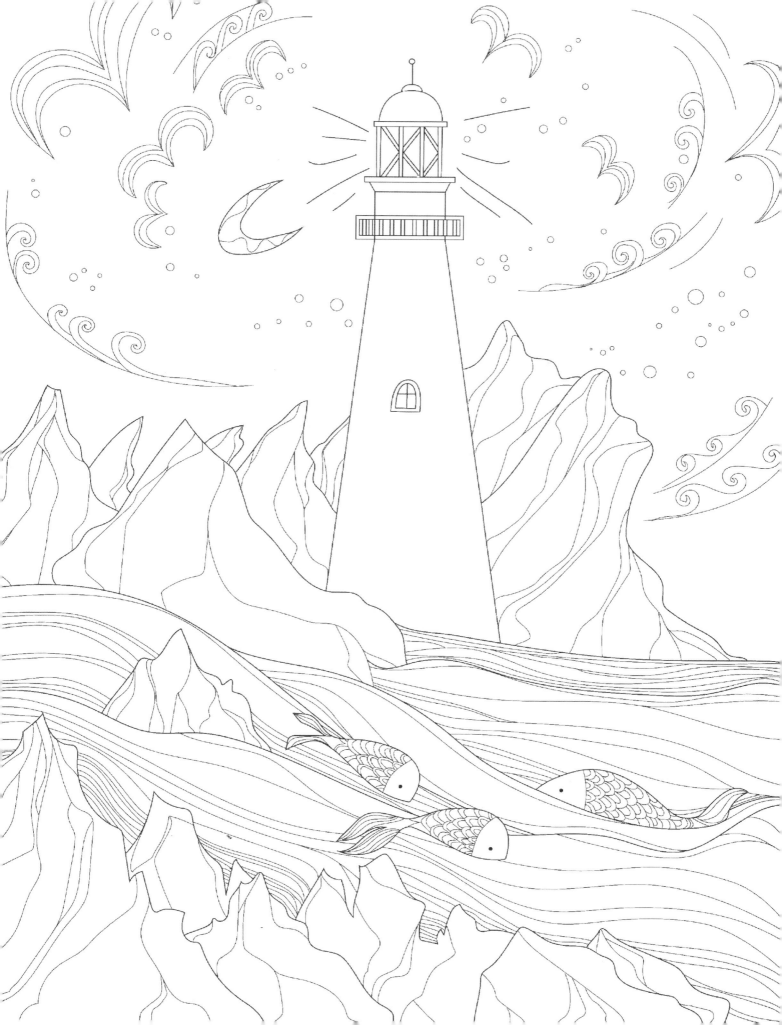

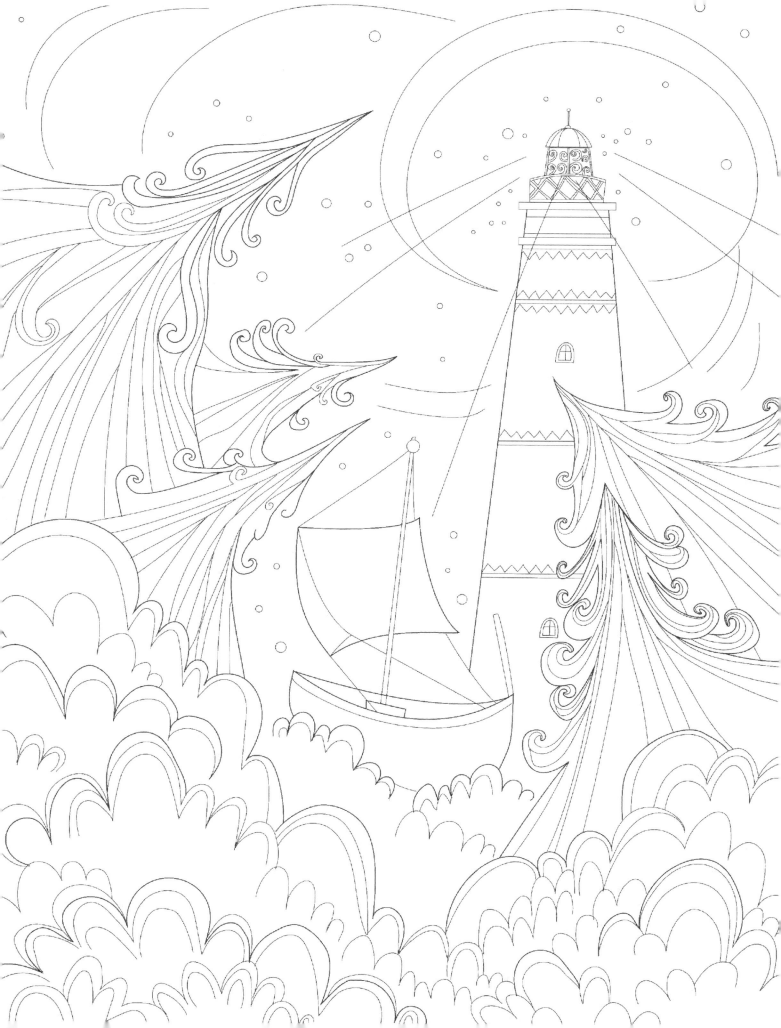

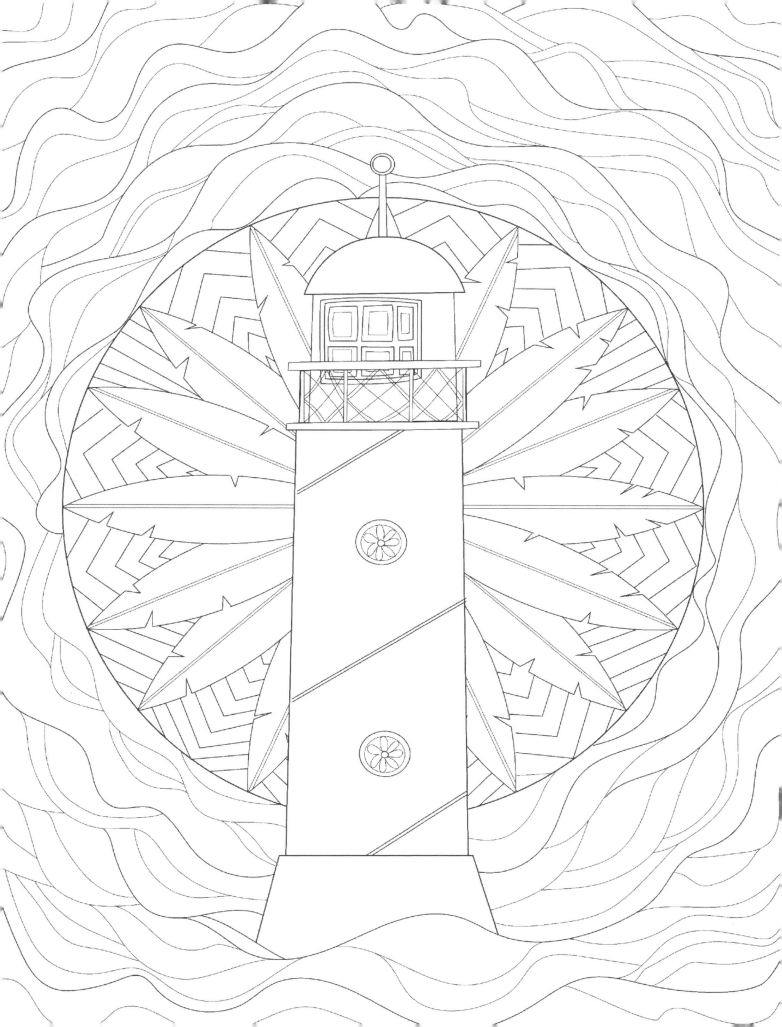

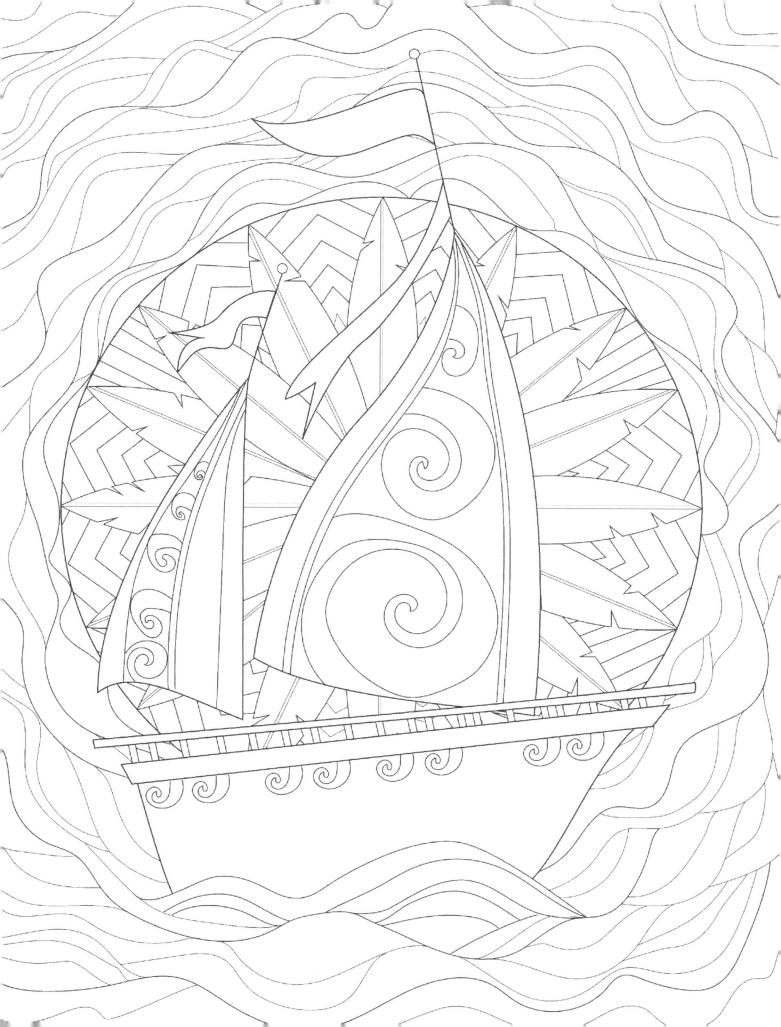

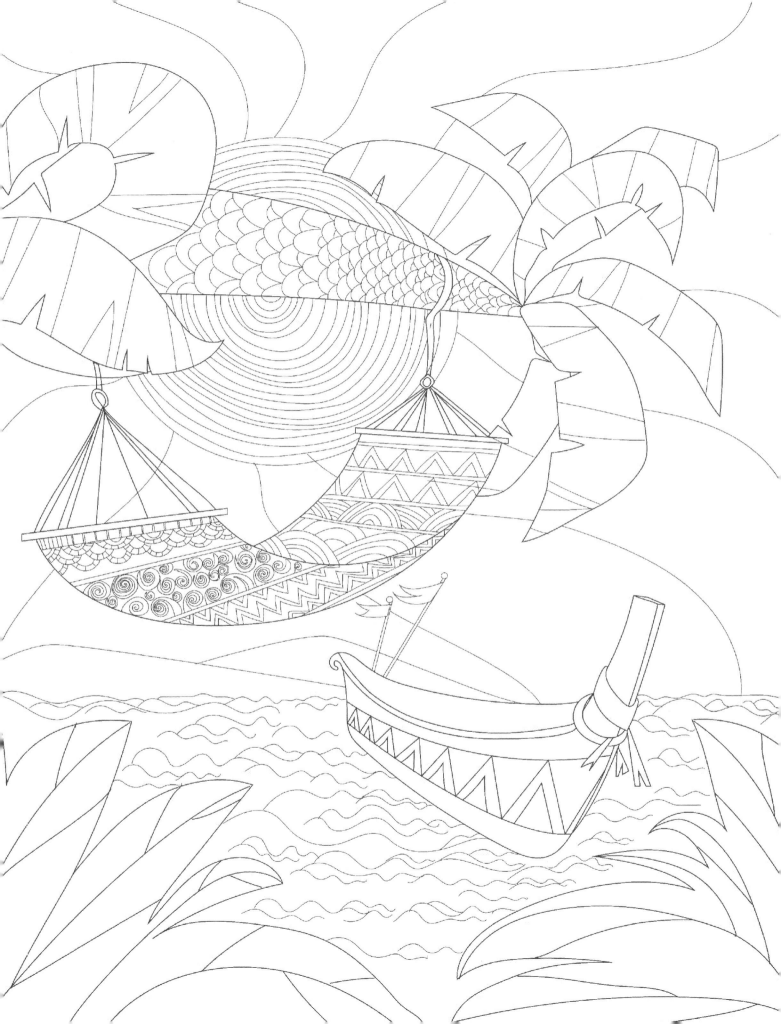

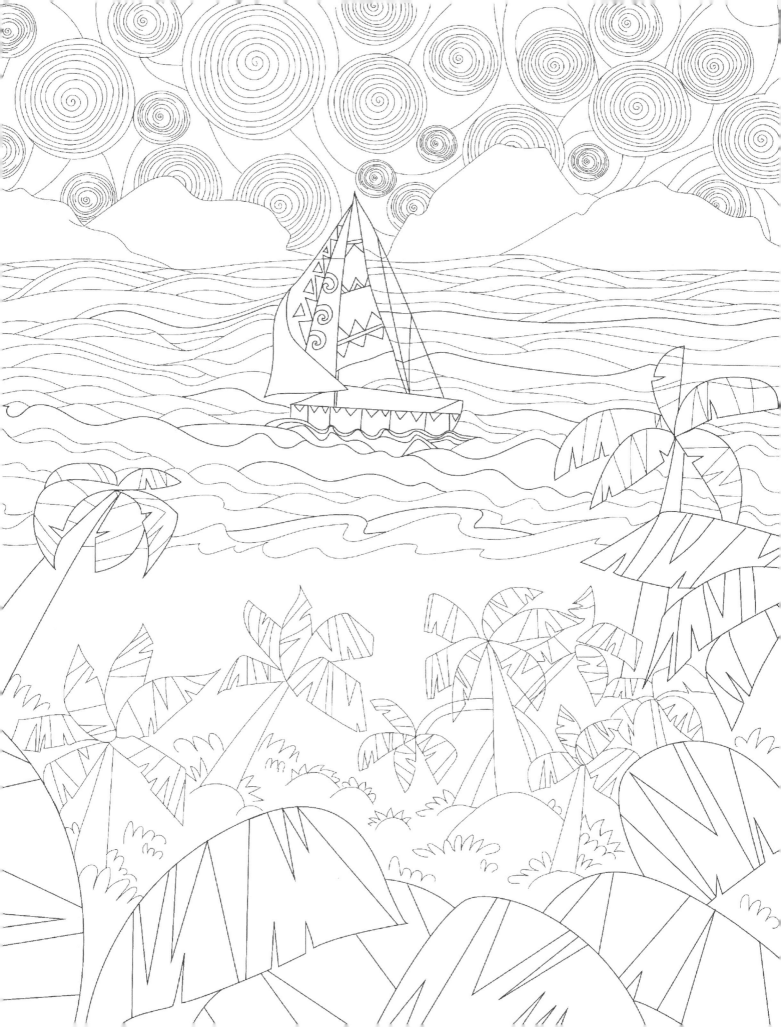

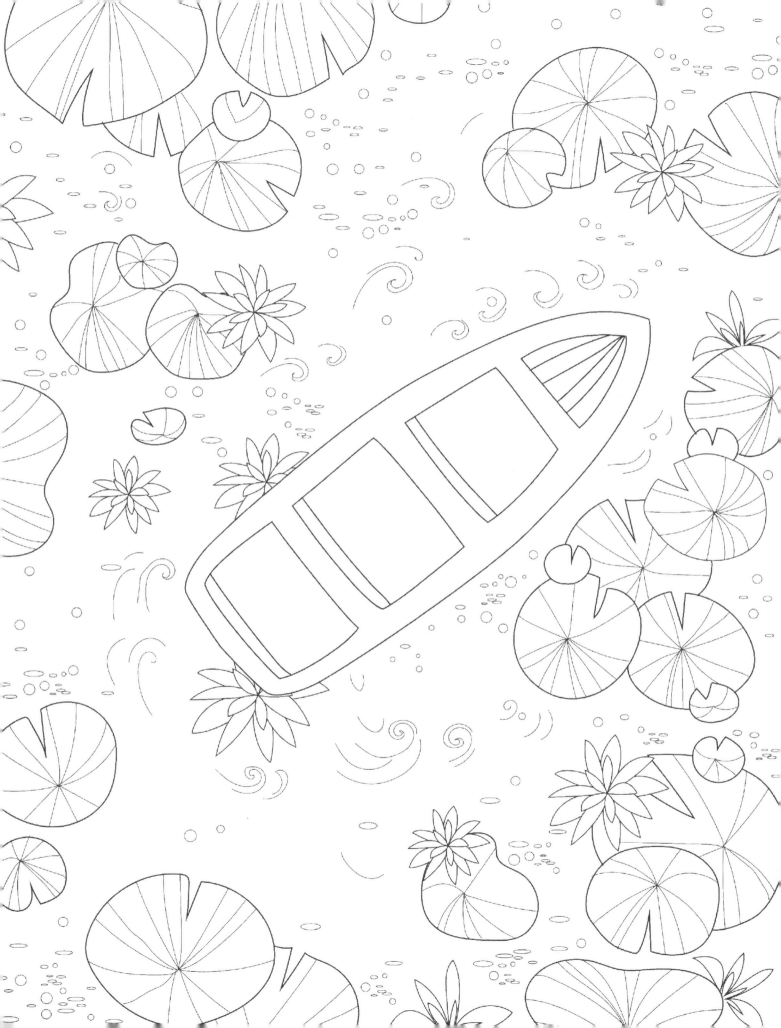

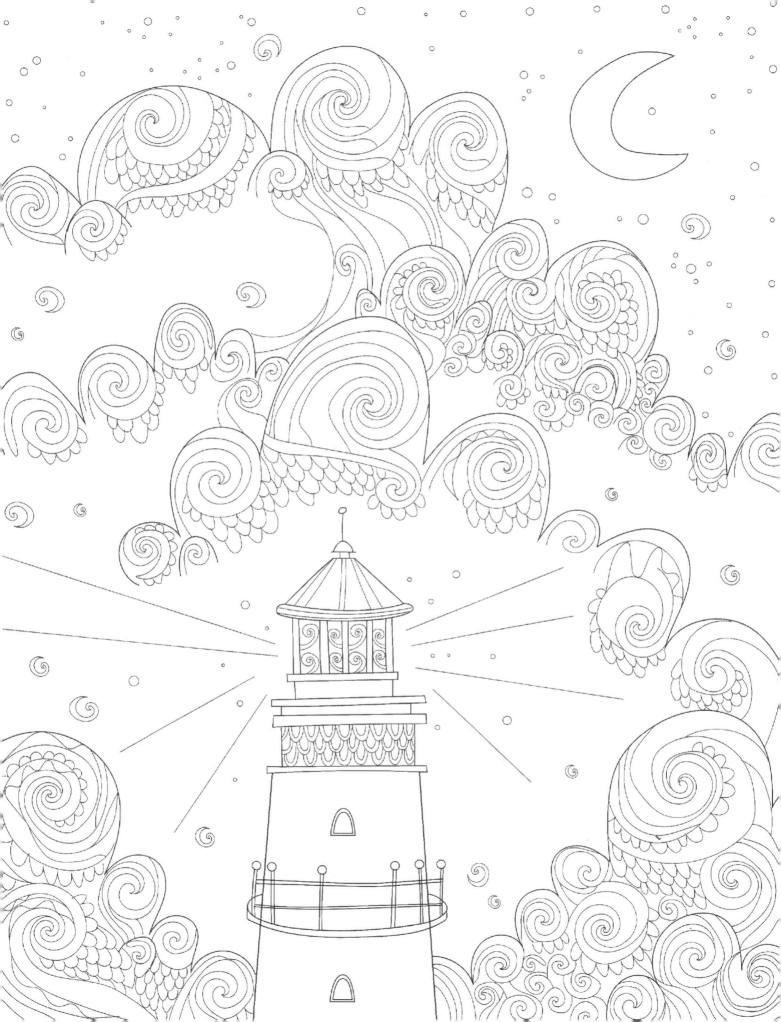

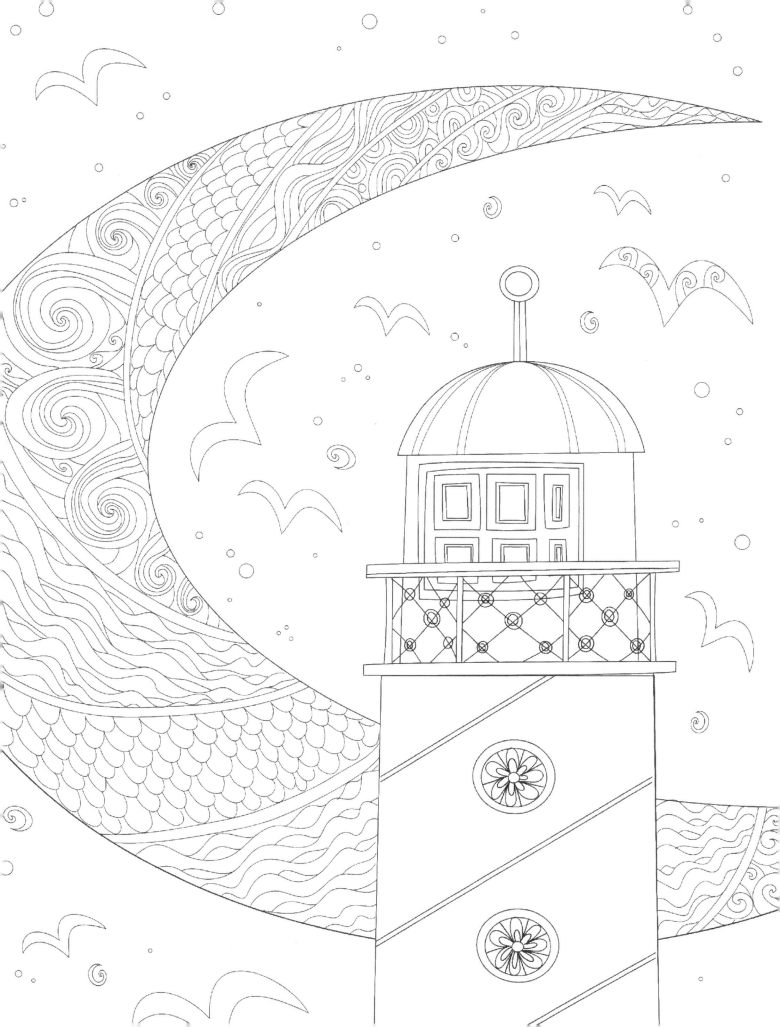

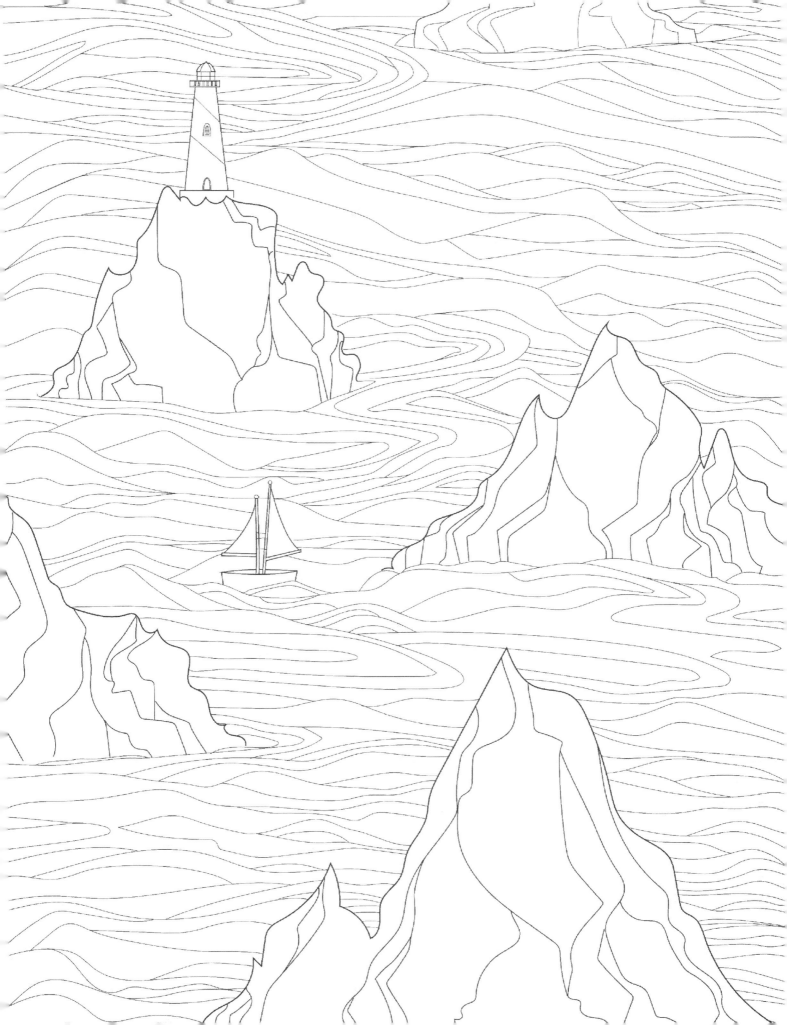

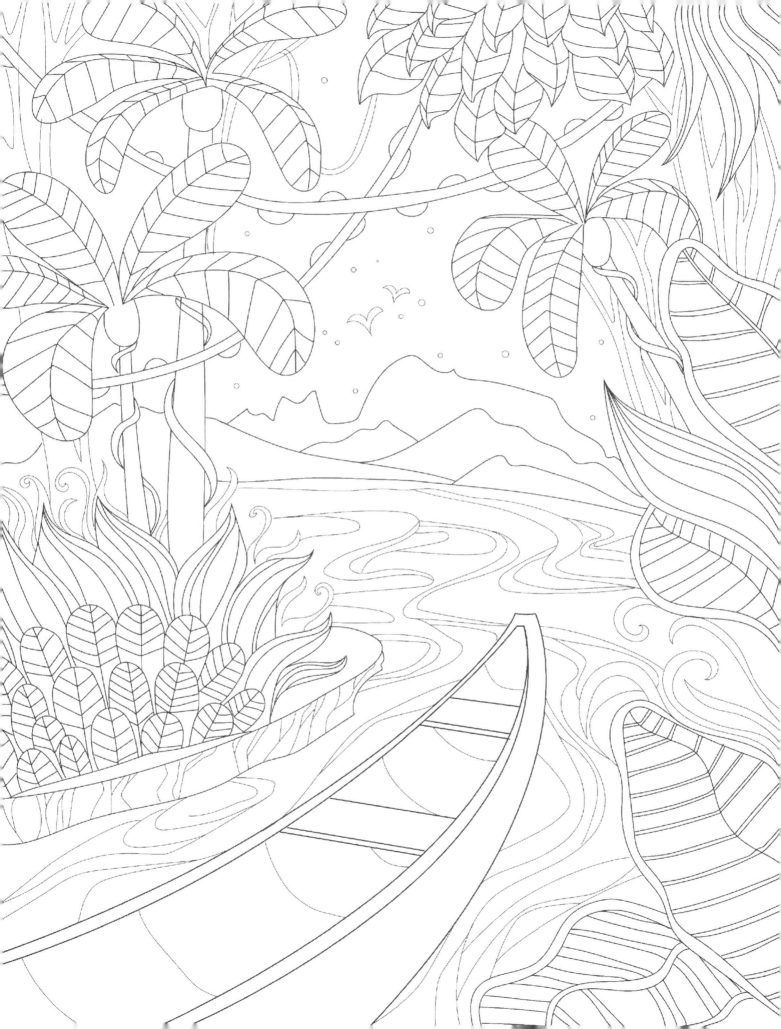

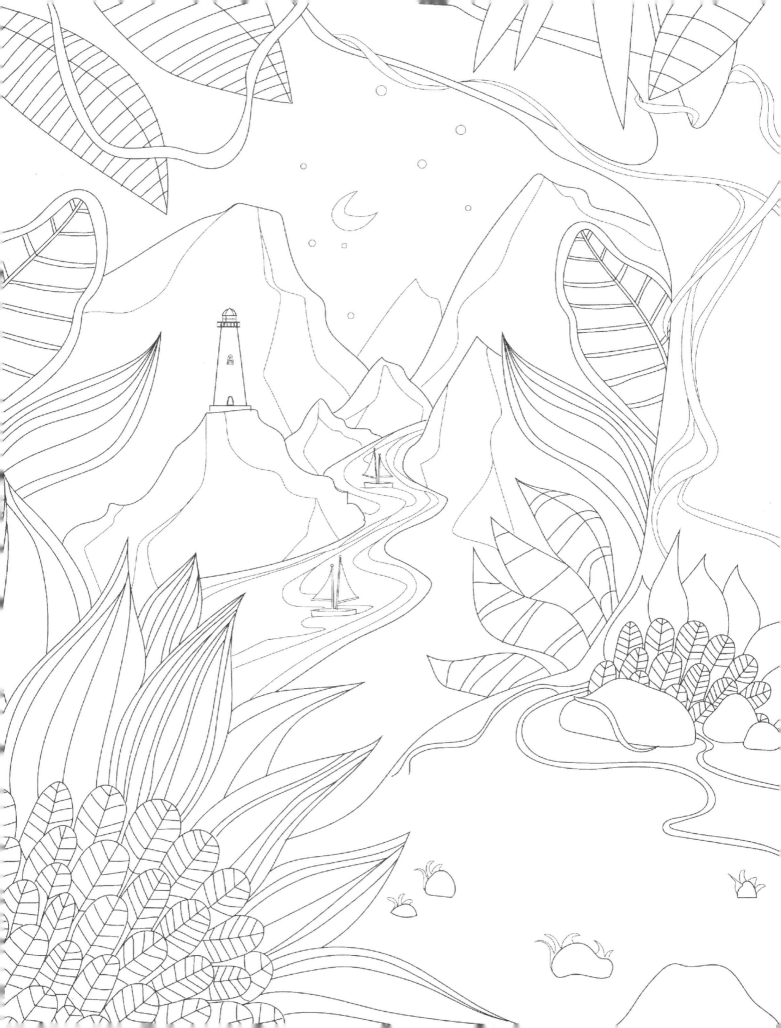

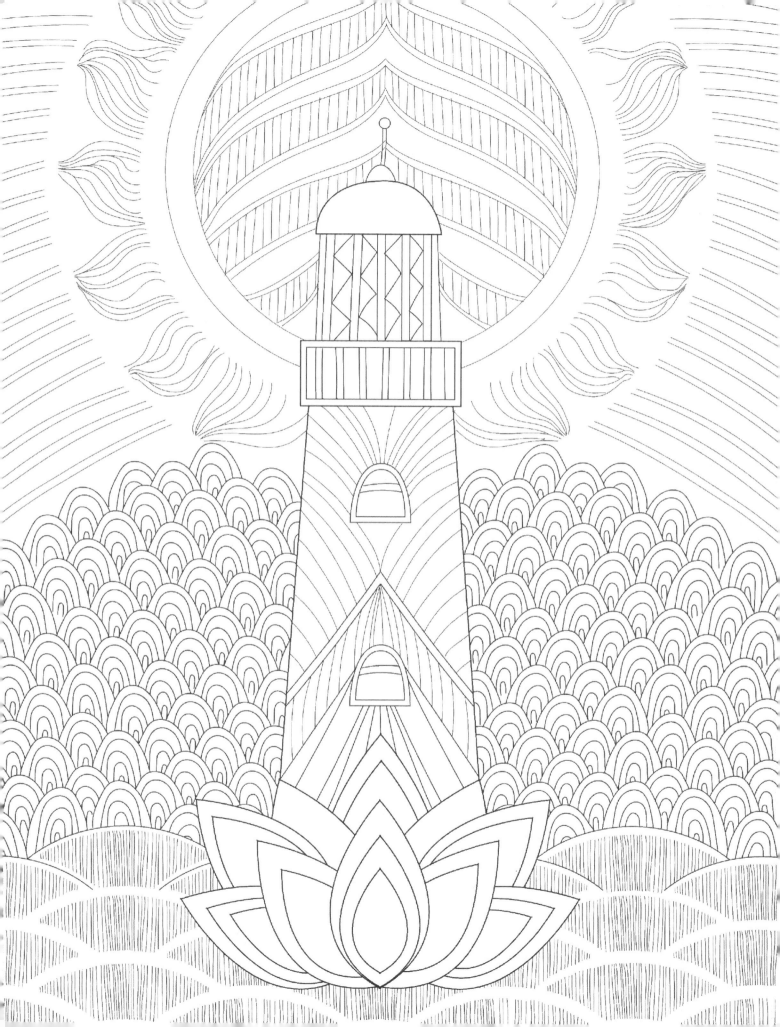

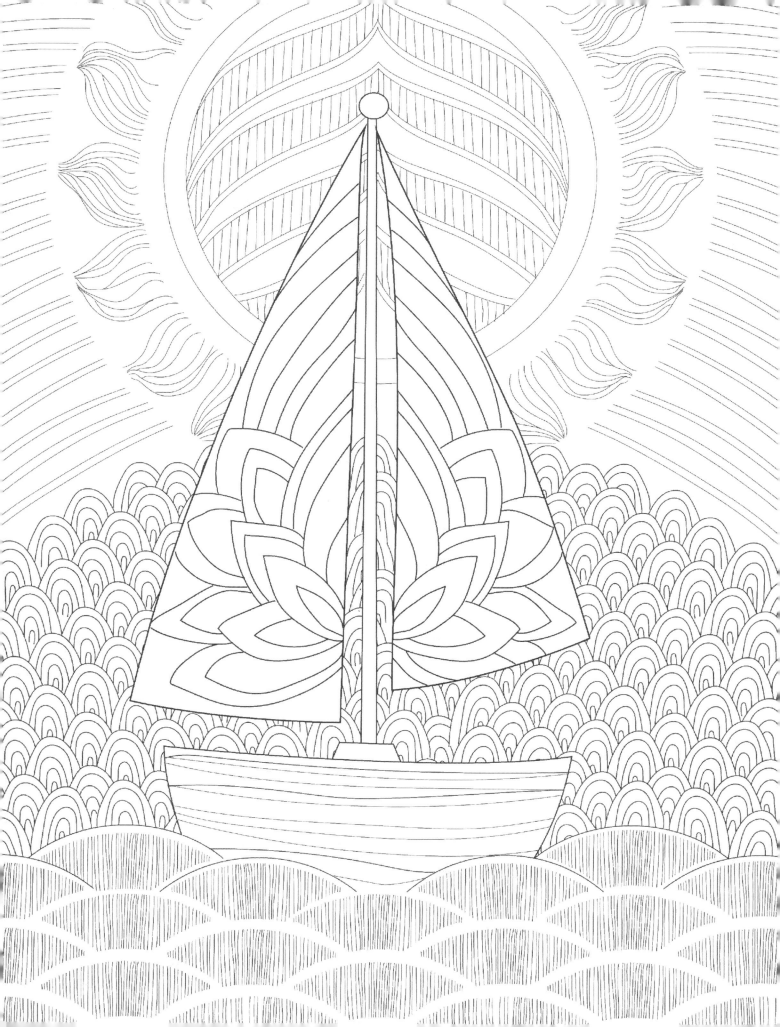

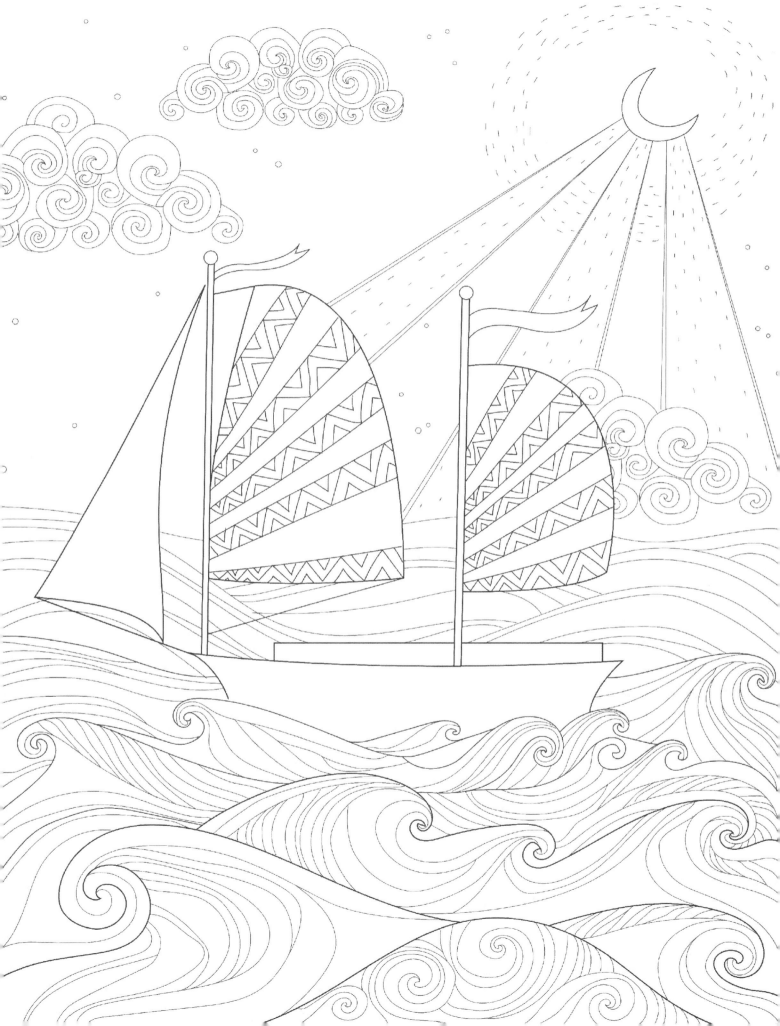

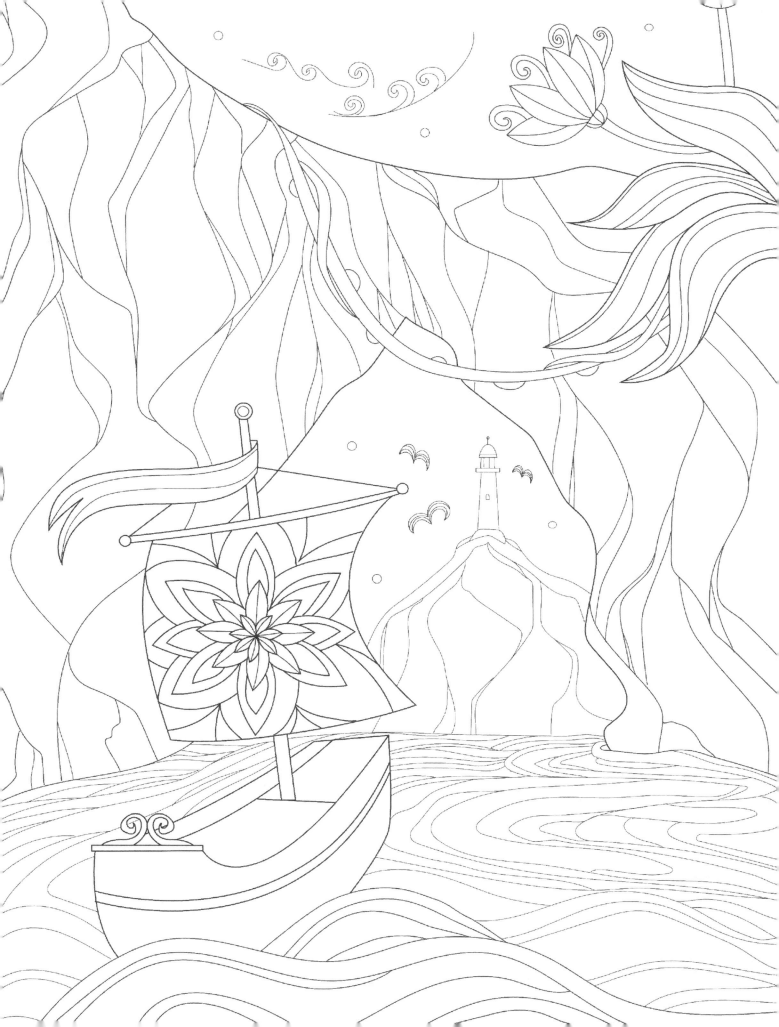

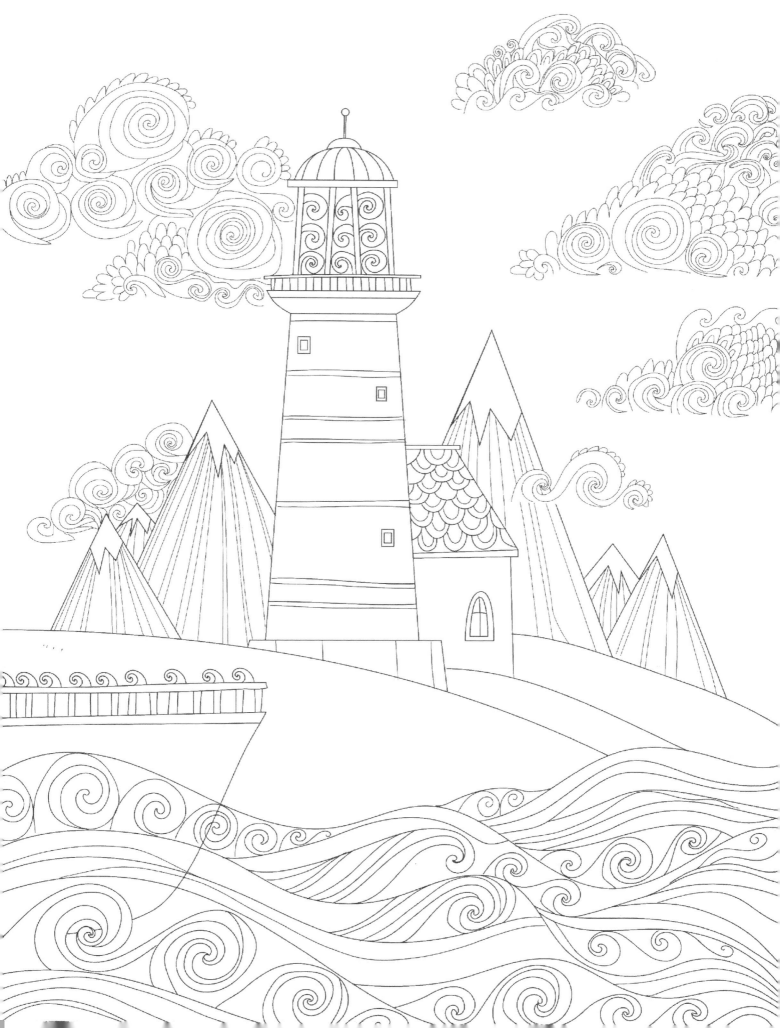

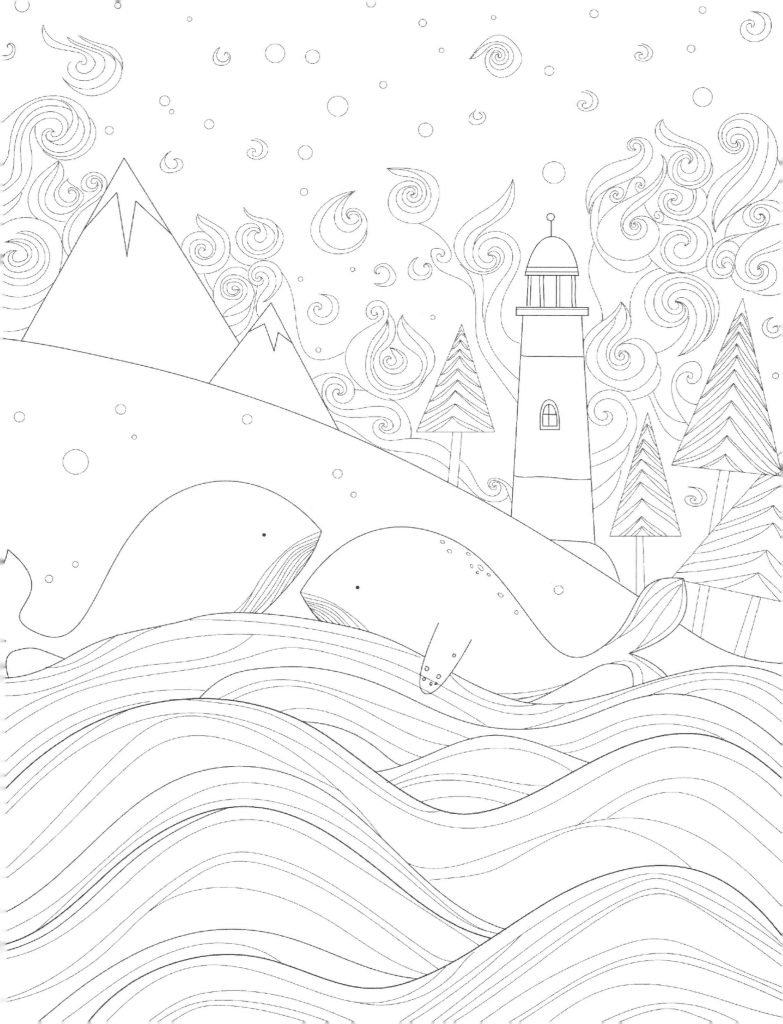

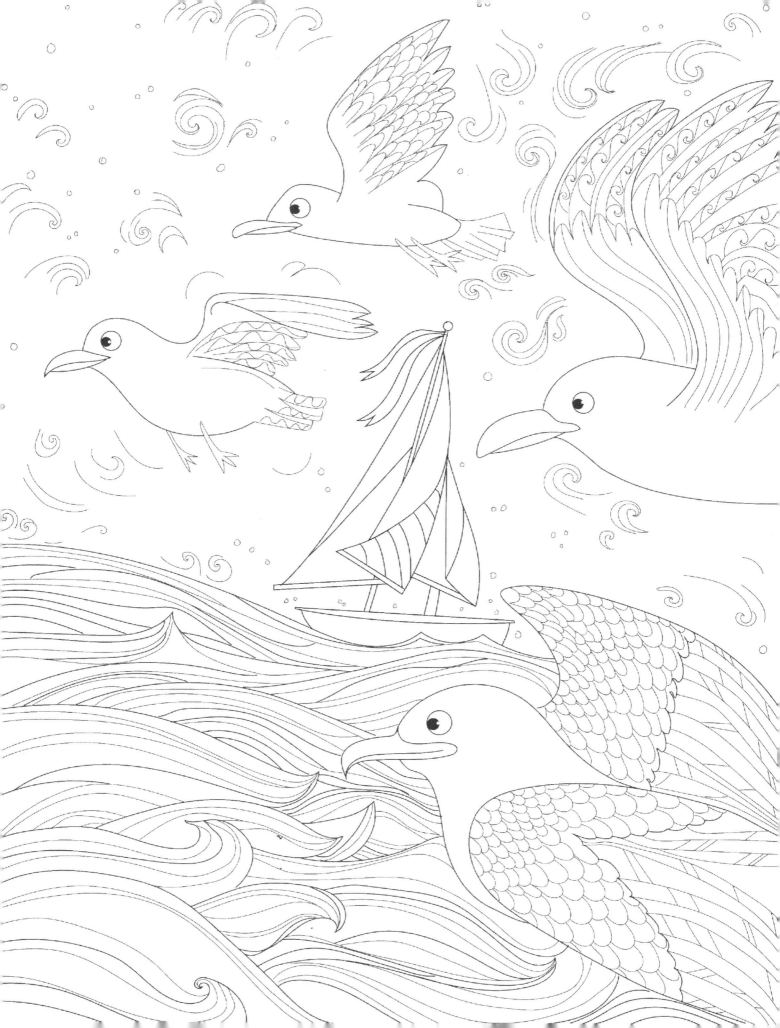

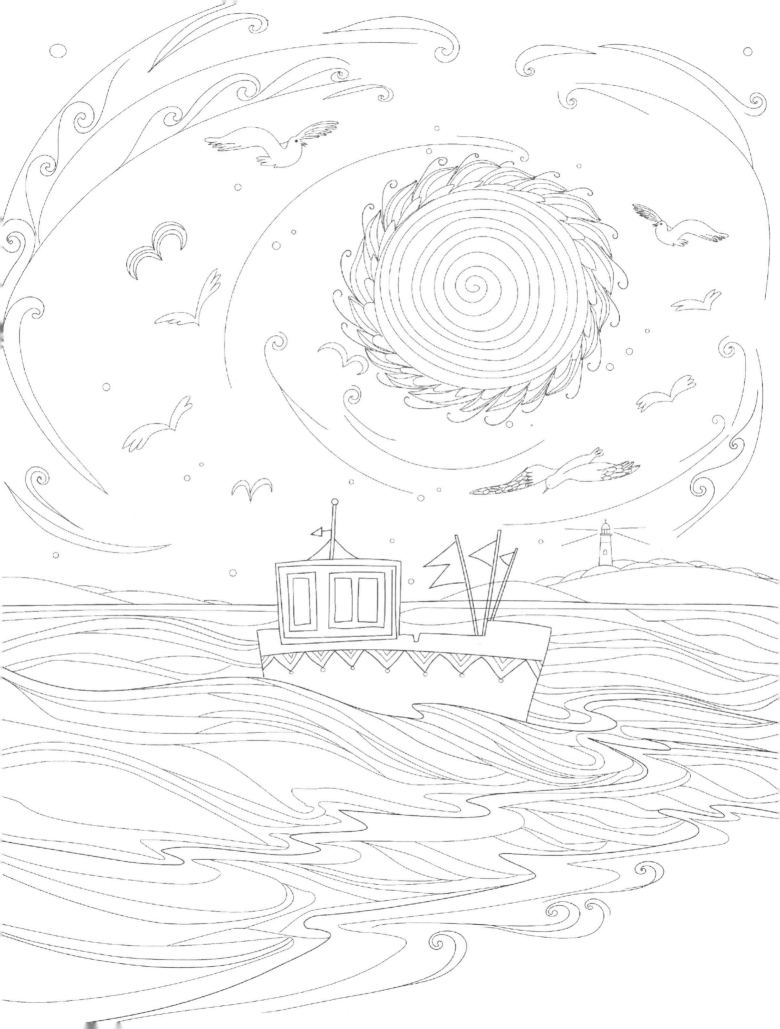

Did you enjoy this book?

Please share your pictures and follow us on Amazon.com

We are endlessly grateful for feedback!

Please leave us a review on Amazon and Google!

Made in United States
Orlando, FL
18 October 2024